PURPLE HEARTS
Back from Iraq

Photographs and interviews by Nina Berman

The soldiers in this book represent a small number of the 7,532 American soldiers who were wounded in action and the estimated 17,000 others injured in combat support during the first eighteen months of the U.S. invasion and occupation of Iraq.

These combat support or non-hostile injuries are omitted from the Pentagon casualty reports even though many of these soldiers medically evacuated from Iraq because of friendly fire, sickness, accidents and psychological trauma, are permanently damaged and disabled.

Iraqi casualties are not counted at all.

Nina Berman, New York City
October 1, 2004

It's hard to say just when the word "hero" went bankrupt. But in the aftermath of 9/11, America became, to its own mind, a nation of heroes. We spread the word around like butter on toast. It has become cultural pabulum, a national panacea, a psychological commonplace. Children are now encouraged by well-meaning adults to grow up to become their own heroes, as if that wouldn't make them insufferable. And yet in a nation that is sick with celebrity, the word "hero" works in strange ways. We fear the elitism of the word, and so we democratize it, bestowing it everywhere, without really understanding what we're doing. In the past few years, our overuse of the word has trivialized the notion of duty and diminished the idea of professionalism. We say the word "hero" so much that we must be very afraid, as if a world full of heroes felt safer or at least more interesting. Somehow our lives suddenly seem to require heroism to sustain them. It's the password in an insecure world, the mantra we use against the dullness of ordinary life.

The subject of these photographs are soldiers who were wounded in Iraq. Three of them were wounded in firefights. One was delivering ice. Another walked off into the desert on a bathroom break and stepped on a mine. One was wounded while blowing up a munitions dump. Another had a grenade flung into his humvee. The youngest of them all was wounded by a suicide bomber. Two of the soldiers who look the least damaged are blind, far more damaged than the camera can record. One soldier whose limbs are intact and who appears nearly normal is brain damaged. A metal chunk from a bomb pierced his brain and left him a stranger to his family.

Whatever they may feel about their condition now, these men tend to sum up the war in Iraq in simple, blunt, sometimes shocking phrases. "It was the best experience of my life," said a twenty-one year old who was tossed around as a youngster and landed in Iraq only to come home blind and without a leg. Or this from a double amputee: "The reasons for going to war were bogus, but we were right to go in there. Saddam was a bad guy."

No one has the right to say that these soldiers are not heroes. But I also suspect that few people understand the contemporary hollowness of that word better than they do. To a soldier coming home from war, the word "hero" looks surprisingly like a gesture of incomprehension, especially in our time when the word is on everyone's lips. It measures the appalling gap between civilians and soldiers, the inexplicable difference between peace and war.

Verlyn Klinkenborg, New York City

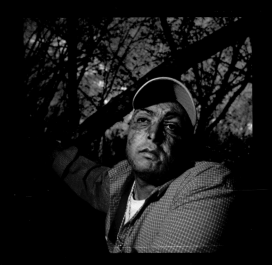

Spc. Jose Martinez, 20, 101st Airborne, was injured April 5, 2003 in Karbala when the humvee he was driving hit a land mine. Martinez was trapped in the explosion and suffered massive burns to his face, head and body. He has spent the last year in surgery and recovery at Brooke Army Medical Center in Texas.

Photographed at his home in Dalton, Georgia, while on a brief hospital leave, April 3, 2004

"I'm this great picture
of the Army"

I had this dream where everything was going to work so good and everything would be fine. Three years in the Army. I'll be in and out. Now I look back and think about my thoughts and I think all it was, was a fantasy. That's kind of what it was.

I was always considered the pretty boy in high school. I was always told cute, handsome whatever. And I always relied on my physical appearance. That's why I think sometimes I'm glad this happened to me because it made me open my eyes. It's actually who you are inside that makes a difference.

I was going through a great deal of pain and then they put me on a ventilator. I was on a ventilator for 19 days. I couldn't close my eyes because of the fact that the burns on my face were pulling my eyelids. I had to have 8 surgeries done on both eyes. They would put cream in my eyes, you would just try so hard to dream into the sleep, I really didn't get any sleep.

I want to stay in the Army. It's just something I got addicted to and I like it. I'm this great Army soldier. I'm this great picture of the Army.

The biggest issue is freedom. We do things and soldiers do things so that their kids can sit at home and watch TV and not have to worry about what's going to happen. My Mom would always ask me, "Do you like playing Play Station?" And I would say, "yeah," and she was like, "That's why they're doing that (the soldiers in Desert Storm), so you can sit at home and you don't have to worry about anything."

When I came home for the first time that's all I heard, "You are a hero." And I say thank you. I appreciate that. That title is a big thing. I've been very fortunate to benefit from how things have worked out for me.

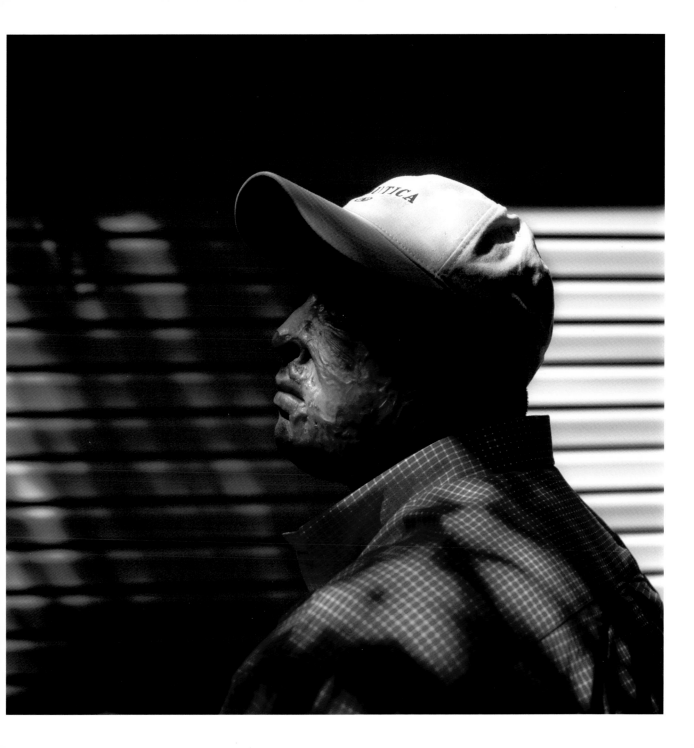

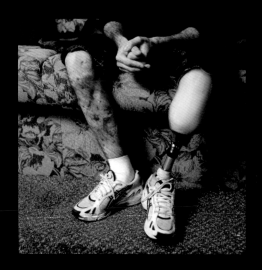

Spc. Sam Ross, 21, combat engineer, 82nd Airborne Division, was injured May 18, 2003 in Baghdad when a bomb blew up during a munitions disposal operation. He is blind and an amputee.

Photographed in the woods near his trailer where he lives alone in Dunbar Township, Pennsylvania, October 19, 2003

"It was the best experience of my life"

I lost my left leg, just below the knee. Lost my eyesight, which is still unsettled about whether it will come back or not. I have shrapnel in pretty much every part of my body. Got my finger blown off. It don't work right. I had a hole blown through my right leg. Had 3 skin grafts to try and repair it. It's not too bad right now. It hurts a lot, that's about it. You know not really anything major. Just little things. I get headaches. I have a piece of shrapnel in my neck that came up through my vest and went into my throat and it's sitting behind my trachea, and when I swallow it kind of feels like I have a pill in my throat. Some stuff like that. And my left ear, it don't work either.

I don't have any regrets. No not at all. It was the best experience of my life. Twenty-one years old and I've seen a couple of countries. I've been pretty much everywhere and done everything. I've jumped out of airplanes. I got to play with mines. I got to see how the army works. I got to go mess around with a bunch of guys that feel the same way that I do, that all enjoy it. I got to inter-act with people of another culture, people who live their lives 100 percent different than the way we live here.

I have one brother and one sister. Couldn't tell you where they live. For a while we grew up together. Mother? Father? Well they both exist. They're both alive, but circumstances regarding the relationship are kind of complicated.

I sleep. I don't do anything really. Ain't nothing really to do around here. It's a shit hole. Same thing it was when I left.

One of the biggest things that's wrong with people nowadays, they're so anti-military. Not in the sense where they don't want a military, but they don't want our military involved in a conflict. And that's what makes us America.

I want to go into politics. Run for office maybe. This is still secret, but I'm talking with people about working with the army. Going on speaking tours. That kind of thing.

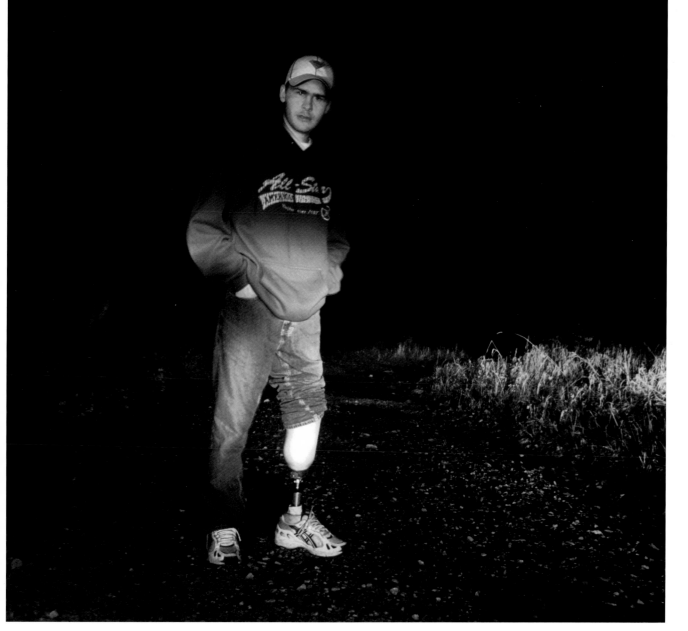

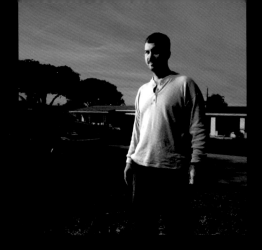

Sgt. John Quincy Adams, 37, a Reservist with the Florida National Guard, 124th Infantry, was on patrol in Ramadi August 29, 2003 when a remote-controlled bomb exploded under his humvee sending shrapnel into his head and body leaving him brain damaged.

"My head doesn't let me work"

I was doing landscaping and lawn service in North Miami with my father-in-law. I loved it. Now I like being with the kids and my wife. I try to be with them always. But the big one likes school and the little one stays behind. I take them both with me and my wife to the Veterans Hospital.

There is not that much I can do now because if I do it and I fall, and I hit my head, it will cause for it to move my brain and the metal I have back here will move. My head doesn't let me work, plus my arm.

I joined the Guard for the money and I liked putting on the uniform.

It was in Jordan I landed and there was, how can I say, it was my destiny and I felt inside me empty because my wife wasn't there, but I knew I had to do it.

I was happy Saddam was caught because my guys will come back soon.

Summer Adams, John's wife: *He can't run. We can't let him run. We can't let him risk falling. He needs a lot of sleep because the medication makes him very drowsy. He's on medication for seizures, mood swings and depression.*

He has metal in the right lower quadrant of the brain. He had a lot of rock and shrapnel that came on the side of his face and he has several entry and exit wounds in the arm which damaged nerves and tendons. And then the mental issue.

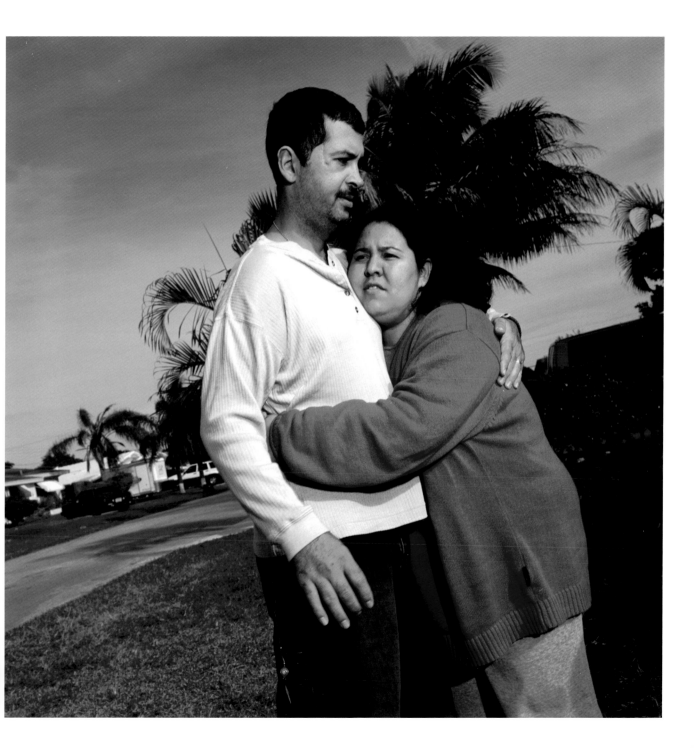

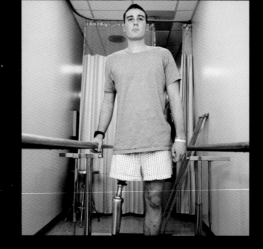

Pfc. Tristan Wyatt, 21, 3rd Armored Cavalry Regiment, lost his leg in a firefight in Falluja on August 25, 2003. Two other soldiers with him also lost their legs.

Photographed at Walter Reed Military Hospital in Washington D.C., October 29, 2003

"I want to go back to the military.
I want my old job back."

We got hit by an RPG. We were in a big firefight. It went right through the vehicle. It was a shitty day to say the least. I just kept shooting. I thought I was dead anyway.

I've had to relearn everything from standing up to walking. I'd been snowboarding for close to eight years before I got hit, and I'm just hoping to be able to do it again.

I wouldn't have given it up for the world. I just fell in love with it. I think about it everyday. Nothing excites me anymore. I almost feel like I was cheated. I've kind of come to the conclusion that nothing will compare. It all seems pretty mediocre.

When I was a young kid, Desert Storm was going on and it was all over the TV. I used to watch that stuff for hours and hours. I was a big hunter. I always had guns as a child.

I joined October 2002 out of Denver. I probably wouldn't have joined the military unless I knew the opportunity of war was there.

I want to go back to the military. I want my old job back. I was a combat engineer. We blew things up. I felt like my heart was in the right place over there.

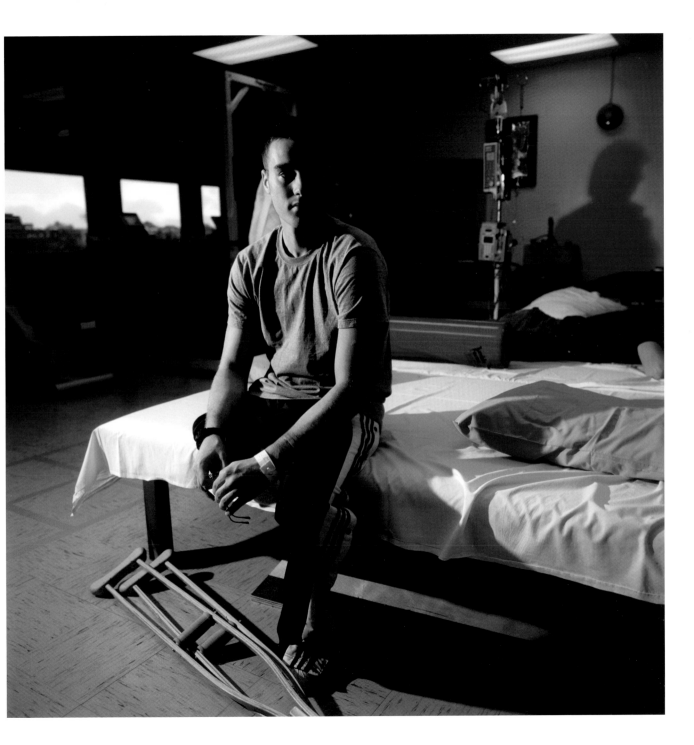

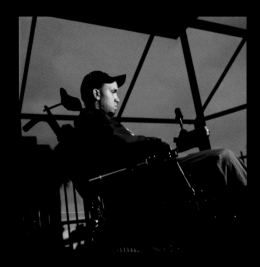

Spc. Luis Calderon, 22, from Puerto Rico, a tank operator, 4th Infantry Division, was injured May 5, 2003 in Tikrit, when a concrete wall with Saddam's face on it, which he was ordered to destroy, came crashing down on his tank severing his spinal cord and leaving him a quadriplegic.

Photographed at the Miami Veterans Hospital, December 17, 2003

"From my neckline down
I can not feel anything"

The wall, it was a mural of Saddam Hussein with his green uniform, beret, and a big rifle pointing to the sky. I was excited, pumped to put the wall down. I was feeling good. I couldn't wait to hit the wall. It was a sunny day, a beautiful day, blue skies. My tank was an M-88. We were five days in Tikrit.

I hit the wall and it just crashed on me and crushed my head and broke my neck and I was dragging the wall still about 100 meters. I felt everything separated, like in relaxing mode, but in reality I was still driving the tank. I couldn't feel my hands on the wheel. I felt nothing. My sergeant was telling me to stop on the radio but I couldn't speak loud because my voice just went away.

I've had three surgeries. My spinal cord is C3-C4 which means quadriplegic. From my neckline down I can not feel anything.

I'm just happy I took the wall down. No regrets. I did my job. I got an Army Commendation medal. I didn't get a Purple Heart. I feel like I deserve one. It would make me more confident that I really did something.

I'm disappointed that when they ask you to go, we go. And when we ask them where is our reward for doing something, they take their time. I don't know. I don't know how the system runs but it's pretty bad.

For the moment right now, I just want to heal.

(Despite his classification as a quadriplegic, Calderon waited more than seven months to be retired and discharged, a difference in benefits of several thousands dollars a month.)

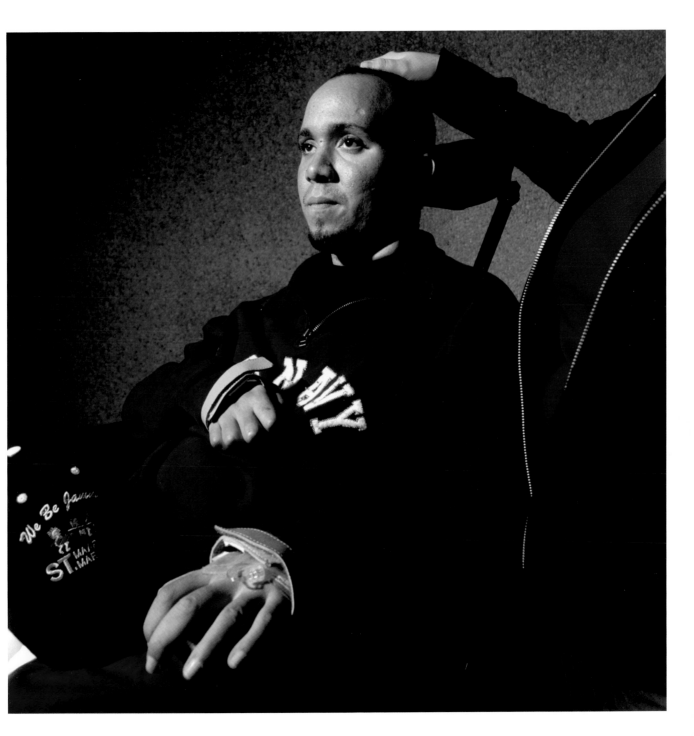

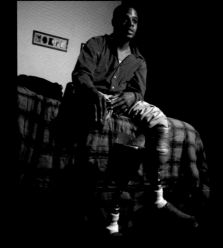

Pfc. Alan Jermaine Lewis, 23, a machine-gunner, 3rd Infantry Division was wounded July 16, 2003 on Highway 8 in Baghdad when the humvee he was driving hit a land mine blowing off both legs, burning his face, and breaking his left arm in 6 places. He was delivering ice to other soldiers at the time.

Photographed at home in Milwaukee, Wisconsin, November 23, 2003

I've always thought about death way before I joined the military, just growing up in Chicago and living out here in this world. I had a friend when I was six years old. His name was Charles and he got killed. He was shot in the head. I think it was a stray bullet. My oldest sister was killed by a stray bullet. I was just a few months old. And my father was killed when I was seven. He was being robbed. So death has always been around.

I remember every detail about my legs. Every detail from the scars to the ingrown toenails to the birthmarks to the burn marks. I made it a habit even before I even joined the military, to cherish every part of my body, cause I would always look at it like, "What if this finger was gone, would I be able to function without it?" Things like that I've always had on my mind. I don't know why, maybe it was God's way of preparing me for what was going to happen.

I've been dealing with the military since I was a sophomore in high school. They came to the school like six times a year all military branches. They had a recruiting station like a block from our high school. It was just right there.

In basic training they break you down and then they try to build you up. But I always had it in my mind that you can't break me down because I know who I am.

I always wanted to go into education and become a teacher but they just don't make enough to survive off. So I figure with my disability now and the money I'll get from the government, I can use that plus the money I'll get from being a teacher and live comfortable. So I want to go to college and study education — public school primarily middle school, six to eighth grade.

The reasons for going to war were bogus but we were right to go in there. Saddam was a bad guy.

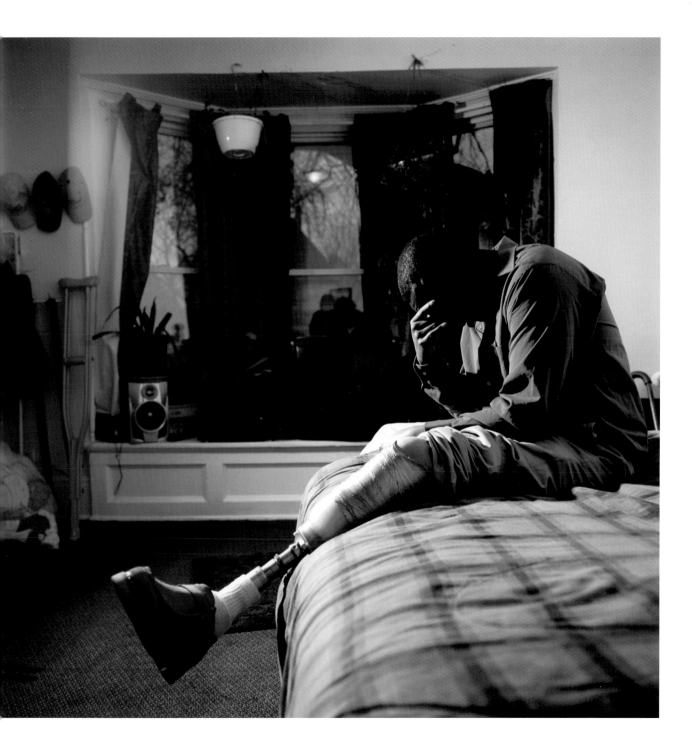

Pfc. Randall Clunen, 19, 101st Airborne, stationed in Tal Afar, was pulling guard December 8, 2003 when a suicide bomber broke through security and exploded himself and his vehicle. Chunks of shrapnel ripped into Clunen's face.

Photographed at his home in Salem, Ohio, February 14, 2004

"I'm an adrenaline junky"

I really have no idea what my mission was. We were trying to catch the people that were doing stuff. Looking for AKs, looking for RPGs, just stuff like that. We found some weapons, but most of the time we would just go to get the people for information. And when we weren't doing that we were sleeping or eating. We had TVs and Play Stations.

I liked it. The excitement. The adrenaline. Never knowing what's going to happen. I mean you could walk in the house and it would blow up. Or you could go in and get fired at. I'm an adrenaline junky and I like that. I want to get out there and hump stuff on my back. That's what I was doing. I was doing what I wanted. I did something with my life instead of sitting around and doing nothing.

Yeah they (Iraqis) were scared. You have like nine Americans busting into your house just screaming pointing weapons. Yeah they were scared. We would go in when they were sleeping and we would just bust in and wake them up so they didn't have enough time to get their stuff.

I have no political feelings. I'm just a soldier out there. You know, we're trying to help them live like us so they can be free and not be scared to do anything. Trying to set them free. That's how we looked at it. Sometimes we hated being over there because they just didn't respect what we were doing. We were trying to help them and they didn't want us there at all.

It was a car bomb. A suicide bomber. He came just ripping through the gate and he exploded the car and himself. I got hit. My nose was sitting over here like on the left side of my face and I couldn't breathe so they had to cut a trachea in. I was bleeding extremely bad. They kept me in a room by myself because I was just like really bad looking. I had tubes running all through me.

All the excitement that was going on, now it's nothing. You just watch the news or you watch the war movies on TV. Full Metal Jacket, there's a couple of other ones. I want to find Hamburger Hill, that's a good one about the 101st. My dad, we'd sit there and watch them. A lot of John Wayne movies too, you know the cowboys and Indians, and then the war movies.

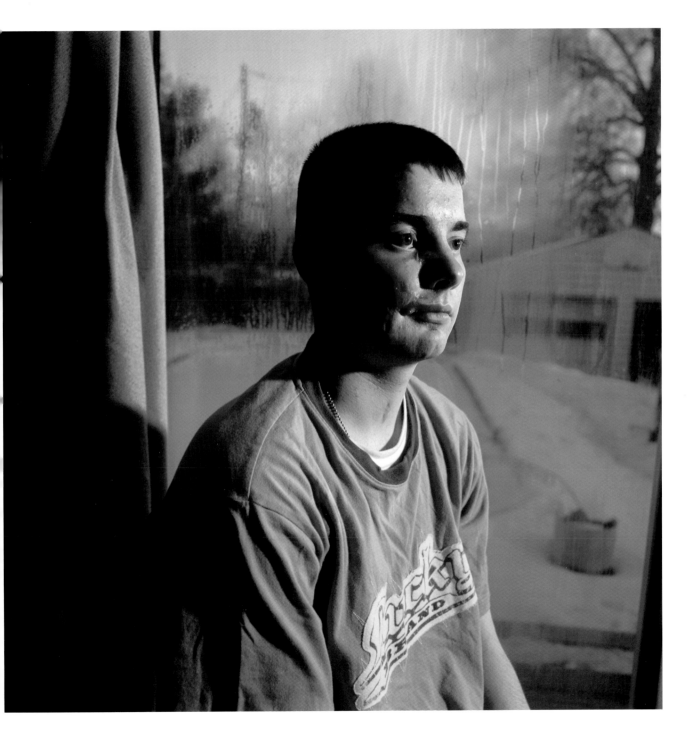

Spc. Corey McGee, 25, a 50-caliber gunner with the 10th Mountain Infantry, was injured in an ambush while backing up Marines in Falluja April 9, 2004. Bullets pierced his neck causing nerve

"We don't know who the bad guy is"

Basically what's wrong with me now is that I had shrapnel in my neck and I was paralyzed because of it. I can't really walk. I can't feel the right side of my face, from shoulder blade to my right ear. I have enormous amount of pain inside my neck. I can't sleep because it hurts so much. I couldn't even eat for a long time. It's hard for my body to keep it down. I can't ask for anything more, just to be alive. I'm going to be better.

Everyday in Iraq you think OK, I made it today, I'm going to make it tomorrow. If it weren't for your buddies lifting up your morale, you would go crazy, you would lose it. There was just so much going on. You were never safe. You can't tell the enemy or who he is. If the bad guys knew that we were only there to help them, if we could show them. But it's so hard because we don't know who the bad guy is. We don't know who to trust.

We made sense of our day by trying to survive every day.

Sometimes you feel hopeless and when you see somebody wave to you, that gives you so much hope for that country and hope for us, for the U.S., so that we will never have 9-11 happen again. I think that's why we're over there, is so that we're bringing it to them, and they're not bringing it to us. Basically, it's the war on terrorism. They're attacking the U.S. soldiers and I consider that to be an attack on the U.S. the land, the sand. To me that's the same thing as 9-11.

I have to say it definitely starts in basic training, that's when you start learning. That's when you start loving your country.

I was a little bothered by that (no WMDs.) I was thinking that we were going in there for a reason and that was one of them, of course we have several other reasons, but when you think that we're searching for weapons of mass destruction and we're not, that kind of leads you to think, OK, if that's not the case, what is to say that the other reasons that we're there, like to say that we're there to build their government, is really happening. It kinds of gives you a little doubt, it does.

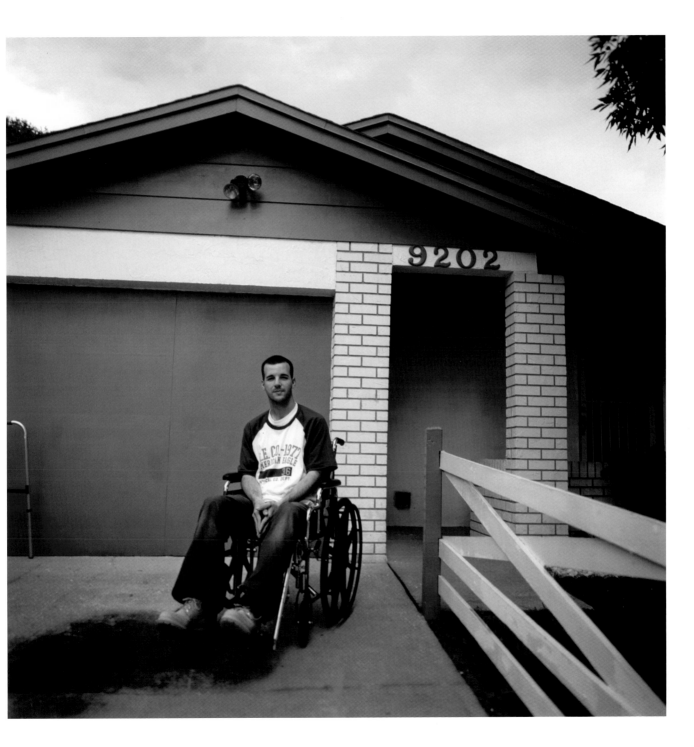

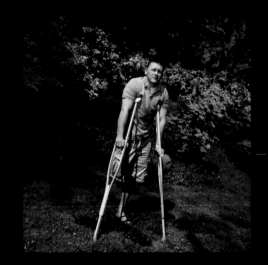

Sgt. Josh Olson, 24, the 101st Airborne, was on patrol in Tal Afar October 22, 2003 when an anti-personnel rocket exploded during a firefight, severing his right leg at the hip.

Photographed on the grounds and in his room at the Walter Reed Military Hospital in Washington, D.C., April 24, 2004

"If they want to go see Allah,
then we'll send them"

Sgt. Josh Olson

*We bent over backwards for these people but they ended up
screwing us over, stabbing us in the back. A lot of them, I mean,
they're going to have to be killed. They're not going to go quietly. I
know that. You have to take them out and kill them.*

*As Americans we've taken it upon ourselves to almost cure the
world's problems I guess, give everybody else a chance, I guess
that's how we're good-hearted. You know from day one, we've
always been about making the world a better place.*

*My personal opinion, I think we should have finished the job in
Vietnam.*

*I'm not really boned up on the whole Muslim religion but from
what I've heard they're all about Allah, and if you're a Muslim
and you die a martyr, heaven for you will be so much better. If
they want to go see Allah, then we'll send them, as long as I get to
go home safe, and my boys get to go home safe.*

*I'm what they call a hip disarticulation, which means I've lost my
complete leg all the way up to the hip, so I just have a hip socket
there. I had a lot of problems with infection. At least eight surger-
ies. The adjustment process is so far so good. Some days are worse
than others. I have a lot of phantom pain.*

*Ever since I was a little kid I always thought being a soldier was
the best thing in the world. You know seeing a soldier in uniform
and on all the TV shows and movies, when soldiers went anywhere
they were treated just awesome, and that's part of being an
American. America's Number 1 and we got to do whatever we
have to do to keep it that way, to keep it free.*

*When the President came in December, that's when I got my Purple
Heart. It was pretty cool. I was real fortunate to live my life's
dream.*

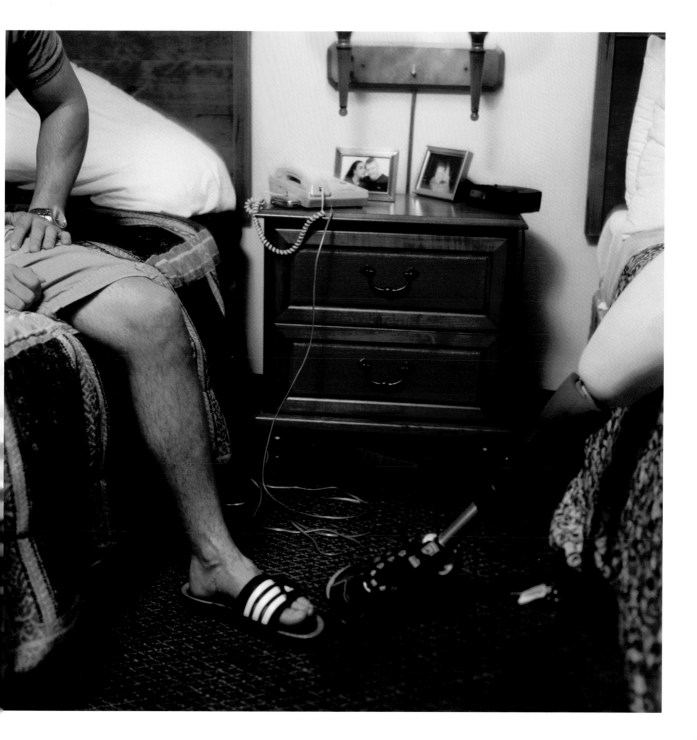

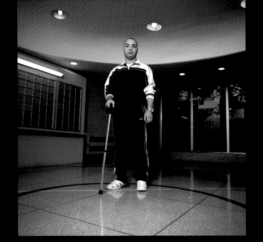

Cpl. Alex Presman, 26, a heavy vehicle operator in the Marine 6th Communication Battalion, was injured outside Baghdad July 15, 2003 when a mine exploded in front of him blowing off his left leg.

Photographed at his apartment in New York City, October 28, 2003

"I think a man has to go through the military"

My father was in the military. In Russia it was mandatory. I came from Russia. I think a man has to go through the military. I always wanted to do that.

I volunteered to go. I could have gotten out, because my Reserve contract was over. I volunteered basically because a couple of my good friends were going and being in the military is what it's all about. It's about doing something. Being in the military action. I just wanted to be a part of it.

Everybody was hyped up. Ready for anything. It happened July 15 in the morning. About forty miles before Baghdad, we stopped for a break and some people went to use the bathroom, four guys in front of me. I was following them, and boom, it took off my foot. It threw me up and I just fell down. At first I was a little shocked, I didn't understand what happened. It was a landmine on the side of the road. I was the only person injured.

At Bethesda they told me that they had to amputate. Nobody can prepare themselves for that.

It's just pride. The brotherhood. The way of life. Being in the military and being the few, the proud. Once a marine, always a marine.

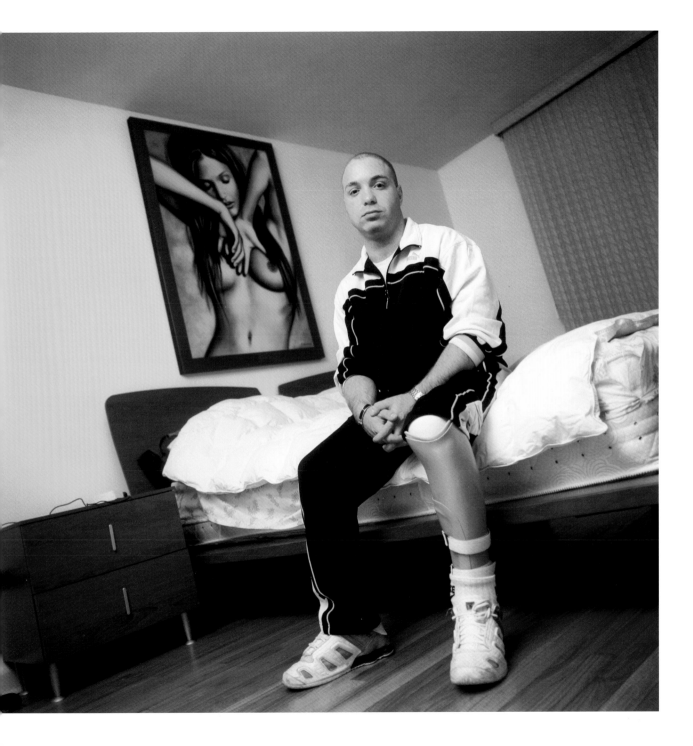

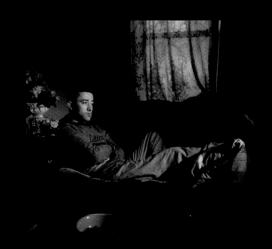

Sgt. Wasim Khan, 24, 1st Armored Division, was pulling security in downtown Baghdad June 1, 2003, when an RPG attack shattered his leg and sliced his body with shrapnel. An immigrant from Pakistan, Khan received his citizenship while recovering at Walter Reed Military Hospital.

Photographed at his home in New York City, January 10, 2004

"Before I came to America,
I thought Americans

I've had a total of seventeen surgeries, two in my eye and fifteen in my leg. I feel the pain. I got to eat something and take my medication. I can't move my leg so I have to keep it up on the couch. I have shrapnel in my arms and my legs. I can feel them, they're moving. In the shower, little pieces are falling out.

I'm not really down to be honest with you. What happened, happened. The way I think, it was supposed to happen that day and I can't do anything about it. The good news is that I'm still alive and God bless I still have both legs.

I feel like I am part of history. In Washington, we go out together, the Korean veterans, the Vietnam veterans and now the Iraqi veterans. This Vietnam veteran brings us milk shakes three times a week on his own to the hospital.

Actually before I came to America, I thought Americans were smarter. But when I talk to them, they don't know about other countries. Even some people don't know American history. I study. I read books. I read the newspaper. I watch the news. You should know about every other country. It's a good thing to know.

When I was here a couple of weeks ago they killed two Pakistani Muslims here in Brooklyn. They were coming from mosque. It was on the news. They called them "Taliban, Taliban," and they shot them. But I've never had any problems.

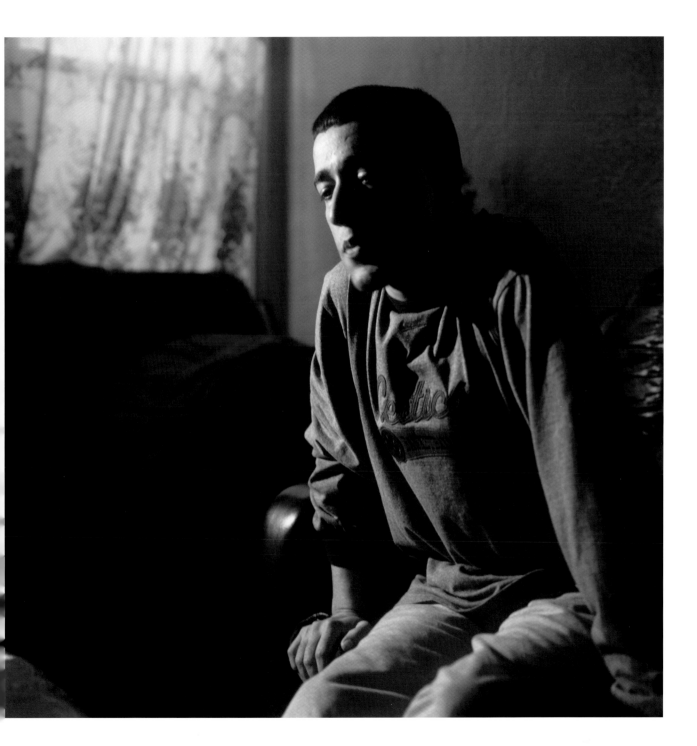

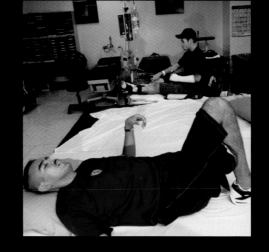

Sgt. Erick Castro, 23, of Santa Ana, California, assigned to the 3rd Armored Cavalry Regiment, lost his leg at the hip when an RPG pierced through his armored personnel carrier in Falluja August 25, 2003. He and two other soldiers, including Tristan Wyatt, each lost a leg in the

"with the prosthetic
I have a lot of control.
I can actually kick someone."

I was born in Mexico — I came here when I was one. I just became a U.S. citizen in December. There was this two-star general at the hospital that asked me, "Hey, are you a citizen?" That same day, I saw Senator Kennedy, and I decided to apply. The director of the INS performed the ceremony in Senator Kennedy's office.

I met a guy in the Army who thought all Mexicans were illegal. And he was like, "How'd you join the Army if you're illegal?" So I explained to him exactly what it meant to be illegal.

Before, I was just a soldier from another country. Now I have actually done something for my country.

I have to wear a prosthetic. Or if I don't want to wear it, I hop around on crutches. My life has changed a lot… a big distance from where it was before. But I'm actually glad I did it, that I served. I don't regret the injuries, not at all. With the prosthetic, I have a lot of control. I can actually kick someone. My family, they're over the whole injury. I have PTSD (post-traumatic stress disorder), not full blown, but at night, loud noises, like everything else.

It was a shock, the type of lifestyle that people had over there. The poverty that was there. A lot of things we take for granted like running water. I've been in Mexico and Spain but nothing compared to that.

We were the first Americans in Al-Ramadi. They were just kind of scoffing at us, flipping us off. I guess they were expecting us to just leave.

I miss the military, the lifestyle, the whole chain of command. I get bored. Retired at twenty-three.

I got a Purple Heart from the President in Washington. He just came down and handed it to me.

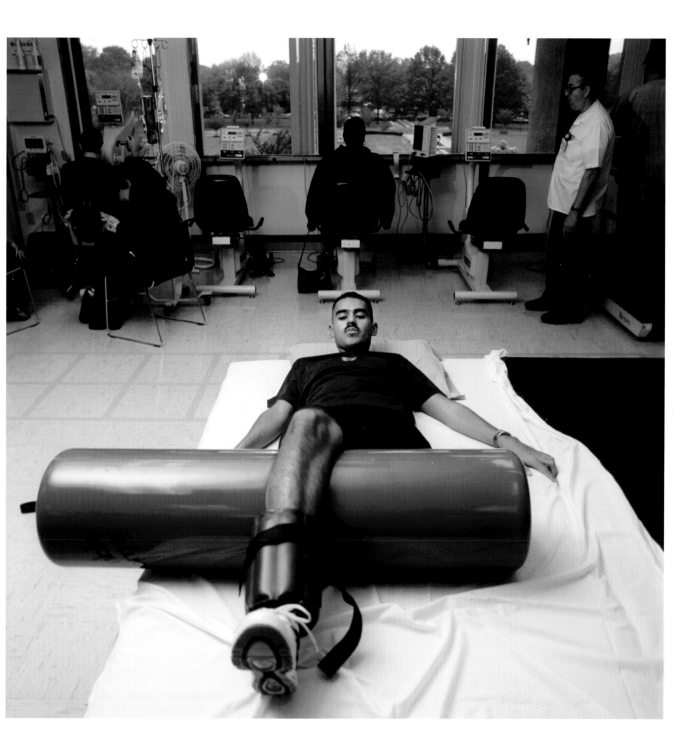

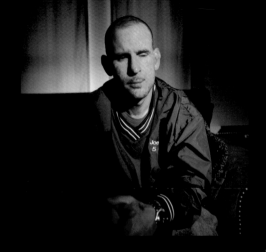

Sgt. Joseph Mosner, 35, 1st Infantry Division, was setting up a guard post in Khalidya on December 16, 2003 when a remote-controlled bomb planted in a side of a building exploded injuring him and two other soldiers.

"There was no good jobs so
I figured this would have been
a good thing"

The blast, I don't remember it. Didn't feel it. I do remember crawling across the ground, my hands and knees, going into the house to get the dismounts out, cause I thought they were hurt.

It took off my scalp, left side of my face, my ear was hanging off, my left ear. I got shrap metal in the chest, shrap metal in my legs from the knees down and both my legs were broken.

We had a good time. We made it fun. All the joking we did and clowning around. After we got hit, we'd give each other high fives and laugh about it. So it was OK, you know getting to do the real thing. It's like playing a sport, you practice, practice, practice, and then game time comes, you know you want to play.

I got hit six or seven other times prior to this one. First time was going up to Iraq. The second time was at night. Four RPGs came right at me. They're real slow so I wasn't too worried about it. Then my gunner identified the fifth guy who was fixing to fire and so we lit those guys up.

Then there was an eight-hour firefight that I didn't get to go on. And then just a couple of other times — by a cemetery we got hit with an RPG. Missed all of us. We detained twenty-one people, Iraqis, all of them guilty.

I joined August of 1987. I was nineteen when I joined. There was nothing out there. There was no good jobs so I figured this would have been a good thing.

Well my dad's retired, he was a sheet metal worker for years. My mother, she works at Walmart right now. We have four children, two sons, two daughters. I would let them know that it's a good thing to get started but I wouldn't force them in any way to go in, (the military). But the thing that they got to understand, you don't start out making $25 an hour, it's something you got to work at.

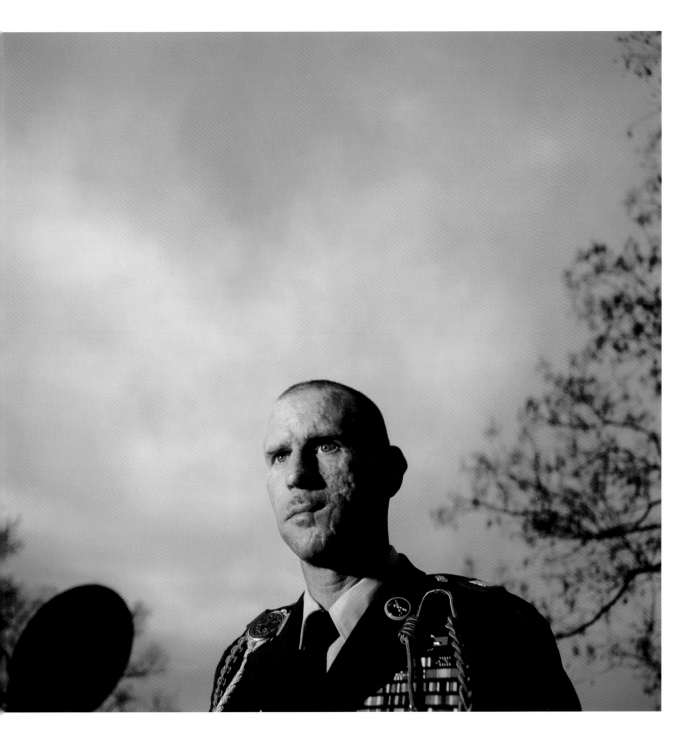

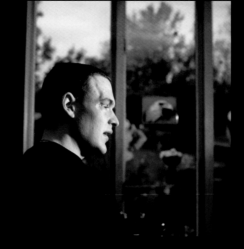

Sgt. Jeremy Feldbusch, 24, a Ranger, 3rd Battalion, 75th Regiment was injured April 3, 2003, during an artillery attack near the Hadithah Dam. Feldbusch, who was first in his class of 228 Rangers, is now brain-damaged and blind. He sees nothing but darkness.

Photographed at his home in Blairsville, Pennsylvania, October 18, 2003

"I knew about the Middle East
as much as I needed"

I graduated from the University of Pittsburgh. I had a great time there. I was a biology major. At one point in my life, I wanted to be a doctor.

Even while I was going through college, I thought about going into the military. And when I was done, it was brought up to me again, about going into the Army, and I thought, you know what, I would like to do that. There were lots of other things I could have done but I was just like, you know, I want to do that. And I talked to recruiters around here, I knew the commander of the recruiting station and he was trying to get me signed.

Before I went, I knew about the Middle East as much as I needed to. But it didn't make a difference. I wasn't fighting a political war with them anyway. That was already taken care of. It was a new kind of war that was going to be fought, so that was where I was stepping in.

That's about it. I don't have any regrets. I had some fun over there. I don't want to talk about the military anymore.

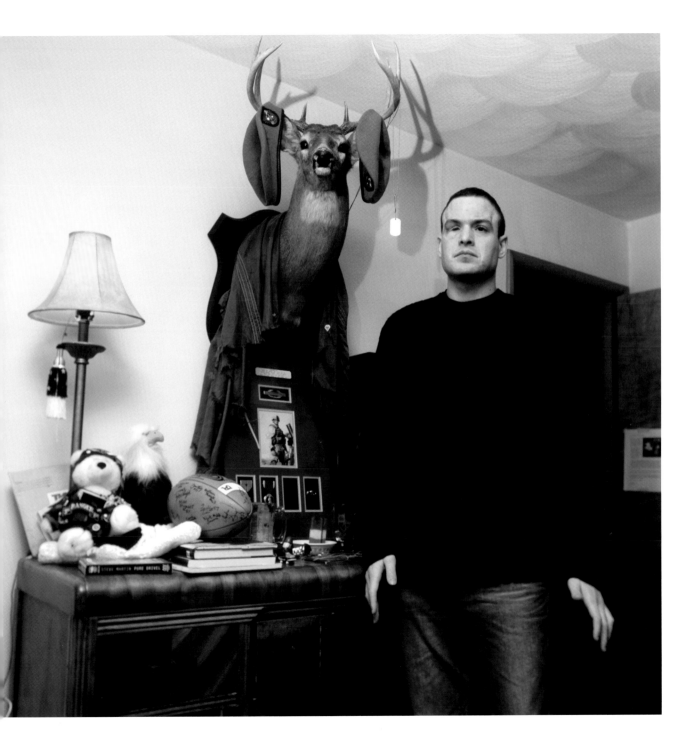

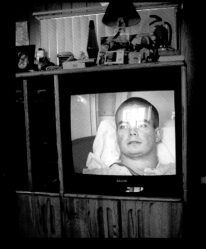

Spc. Frederick Allen Jr, 24, a machine-gunner, 82nd Airborne, was wounded when an RPG ripped through his left leg and shattered his right leg during a firefight in Falluja on October 31, 2003. He has had 15 surgeries and 7 blood transfusions.

Photographed at his parents' trailer home in Pittsfield, Maine, January 18, 2004

"I thought going to war was
jumping out of planes"

It was really quiet and then we heard two booms and an AK and I saw two yellow balls coming at us. It was all slow motion for me because I was hit so it kind of burned an image in my head. It felt like someone had stuck me with a hot poker in the legs. The hit just split it open like if you were to take a hammer to a melon and just smash it open. That's kind of the effect it had on my legs.

The pain is pretty bad at times, just chronic pain all the time. I can't drive. I'm on heavy medication. I used to drive all the time. Now my wife drives. It's hard getting used to the changes. I was always used to doing everything on my own.

Yeah, I feel angry. I've talked to counselors. It helps to talk to people. I wish I could point the finger at one person and just take them on for all the pain and suffering I've been through but there isn't much I can do. I was angry at the people over in Iraq. I don't trust them. I don't like them. I was mad about being over there. I really didn't want to go.

It's different being a dad and being a husband as well as being a soldier. It's very hard. You got to like shut yourself on and off type of thing. It's not that I'm abusive or anything, but it's hard to be calm and patient with my daughter.

I watched Desert Storm on TV when I was a kid. It was interesting for me. I had never really seen anything like that before. You see the sparks flying and the city light up. The firefights that they had. I think Dan Rather was talking on TV.

The recruiters came to school once a year. They had a list of people. Every year they just call random people and once they get one person, then they ask their friends to come. That's how they get people to sign up. He asked me if I wanted to and I said sure.

I thought going to war was jumping out of planes. I thought it would be fun. I didn't know it could be bad until I got to basic training and I saw the movie Saving Private Ryan.

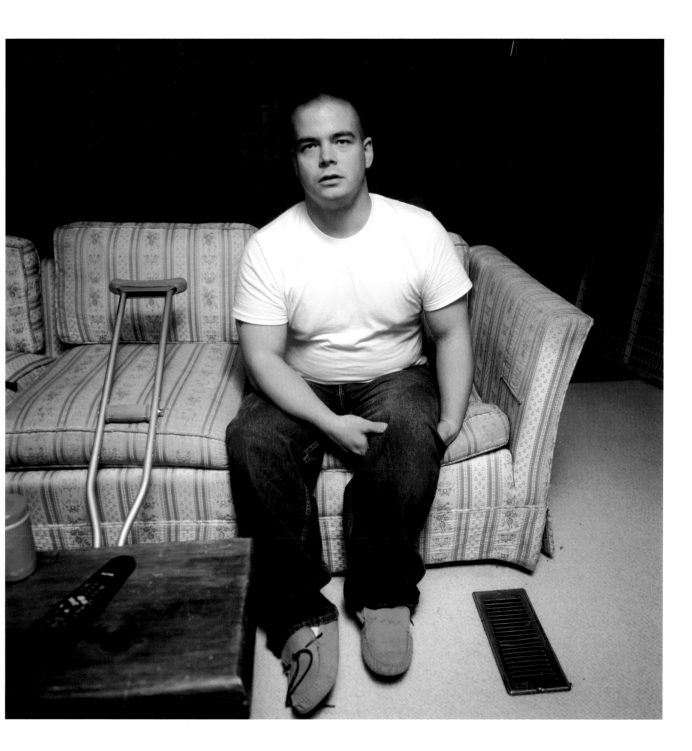

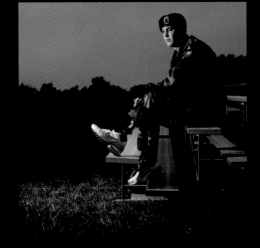

Spc. Adam Zaremba, 20, 1st Armored Division, was injured July 16, 2003 while guarding a bank in Baghdad. A mine exploded blowing off his left leg and sending shrapnel into his rear, right leg, arms and hands. The explosion killed an Iraqi child.

Photographed on base at Ft. Riley, Kansas, April 9, 2004

"You get to wear a cool uniform"

I joined in high school. The recruiter called the house, he was actually looking for my brother and he happened to get me. I think it was because I didn't want to do homework for a while, and then I don't know, you get to wear a cool uniform. It just went on from there. I still don't even understand a lot about the Army.

I thought it was just going to be like higher tensions but I didn't know we were going to go to war. I had no idea. I thought I would be at Ft. Riley just doing my thing.

You always see on TV people getting hurt, and stuff, but you go there and you think you're here, and you think nothing's going to happen.

My one leg was injured the worst, the other one just had like shrapnel wounds and stuff, and my rear got messed up and my hand and my arms.

You hear about all the time, the Purple Heart. That's a good award. But then when it happens, you realize that you have to do something, or something has to happen to you in order to get it. The Chief of Staff of the Army came down and gave it to us. He pinned us and then he had other business to take care of.

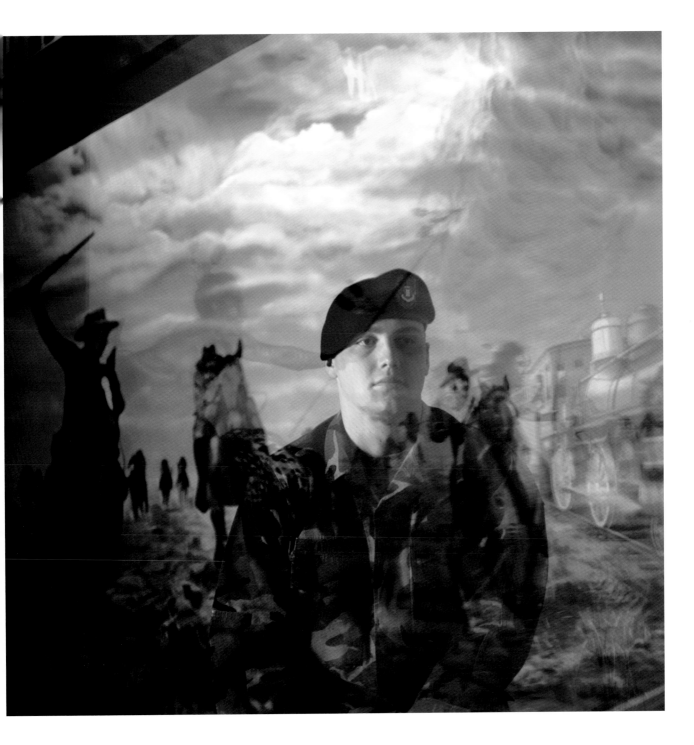

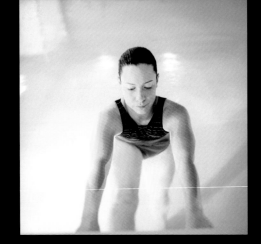

Lt. Jordan Johnson, 23, in charge of a platoon protecting the general of the 1st Armored Division, was en route from Baghdad International Airport July 20, 2003 when her humvee crashed and flipped, smashing her leg and tail bone, and putting her into a coma. Another soldier

"I'm not a hero. I'm a survivor."

I really had a hard time wanting to even be here. They told me last month I have chronic post-traumatic stress syndrome so I meet once a week with a psychologist. It helps to talk to someone. Basically I just can't sleep. I literally only get maybe three or four hours of sleep a night. It's a very restless sleep. It's strange because I wear myself out. I do as much as I can physically and probably too much emotionally. I'm just never tired. I'm tired. I just can't sleep.

When I got to Walter Reed, there were support groups for all the soldiers who got injured in Iraq. I was the only female. It started off people really talking about their injuries, and it just became a woman bashing scenario. I was very uncomfortable. I felt very let down. It would be nice to say that everyone is nice and treats you as equals, but they don't.

Someone asked me the other day, "how does it feel to know that you were going over there and one of your missions was to find WMDs and how does it make you feel to not have found any?" It's disappointing. You go in with a mindset as a soldier that you have a mission. We found Saddam that was amazing. The fact that we haven't found any weapons that's upsetting. So here my brother's gone over there in January, so now what's the mission?

Being part of the United States, what our main goal always seems to be is going in and proving that we're a super power. Why are we trying to prove that?

All I really want out of this is to be able to walk again, to run again. I went from the star athlete to not being able to do six repetitions. It's a very slow process, but I'm dealing with it.

I don't need a medal or any kind of badge or award that says who I am because I know who I am. I'm not a hero. I'm a survivor.

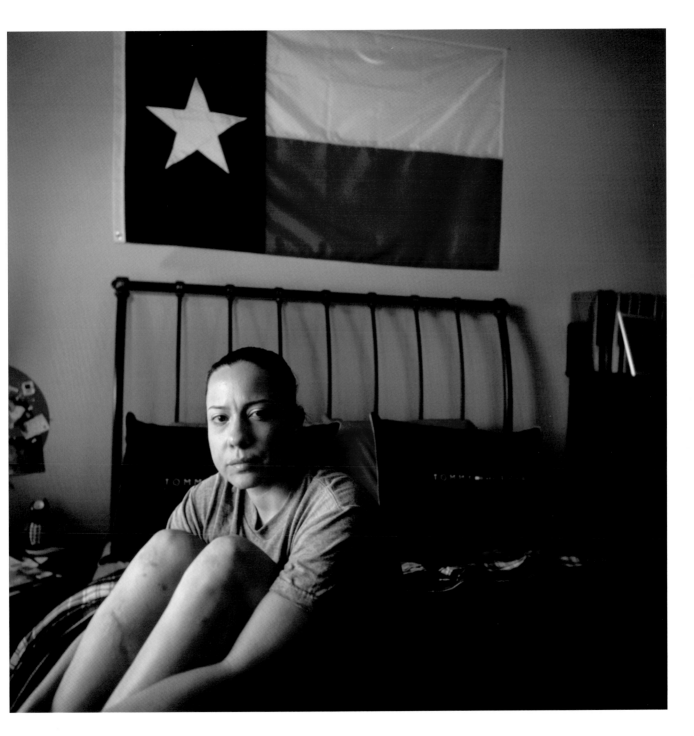

Cpl. Tyson Johnson III, 22, a mechanic with 205 Military Intelligence, was injured in a mortar attack on the Abu Ghraib prison in Baghdad on September 20, 2003. He suffered massive internal injuries and is 100 percent disabled.

Photographed at his home in Prichard, Alabama, May 6, 2004

"I'm burning on the inside.
I'm burning."

We went to the concentration camp there, the prison. I did most of my time over there.

It was crazy. The Iraqis, they wake up about five in the morning and they walking like zombies, just walking, walking, like walking dead type junk. I'm serious.

Most of my friends they were losing it out there. They would do anything to get out of there, do anything. I had one of my guys, he used to tell me, "my wife just had my son, I can't wait to get home and see him." And, you know, he died out there. He sure did and I have to think about that everyday.

Well, uh, shrapnel down the back, shrapnel that came in and hit my head, punctured my lungs. I broke both of my arms. I lost a kidney. My intestines was messed up. They took an artery out of my left leg and put it into this right arm. They pretty much took my life. Pretty much.

I was supposed to be going to physical and occupational therapy then they canceled it because I missed three days in a row. I was throwing up, I couldn't hold anything in my stomach. Now I have to do OT myself. I'm trying to teach my son how to count on his hand. And you can see my fingers is messed up. Sometimes my hands will be so red, so fire red, I'm not able to drive. I've got to put on my gloves. I'm not able to touch anything.

I got a bonus in the National Guards for joining the Army. Now I've got to pay the bonus back and it's $2999. If I would have continued and finished my contract I wouldn't have to pay it back. The Guard wants it back. It's on my credit that I owe them that. I'm burning on the inside. I'm burning.

My high school buddies, well two of them just got found in a ditch around there, dead, dead. And the rest of them in jail, cracked out. For real. That's why after high school, I left. I was gone because I knew where my life was headed. Joined the Army. And here I am, back here. I would love to go away. I would love to go away. I think that would be better. Because I'm driving in my car, I'm doing nothing. I don't know where it's going to end up.

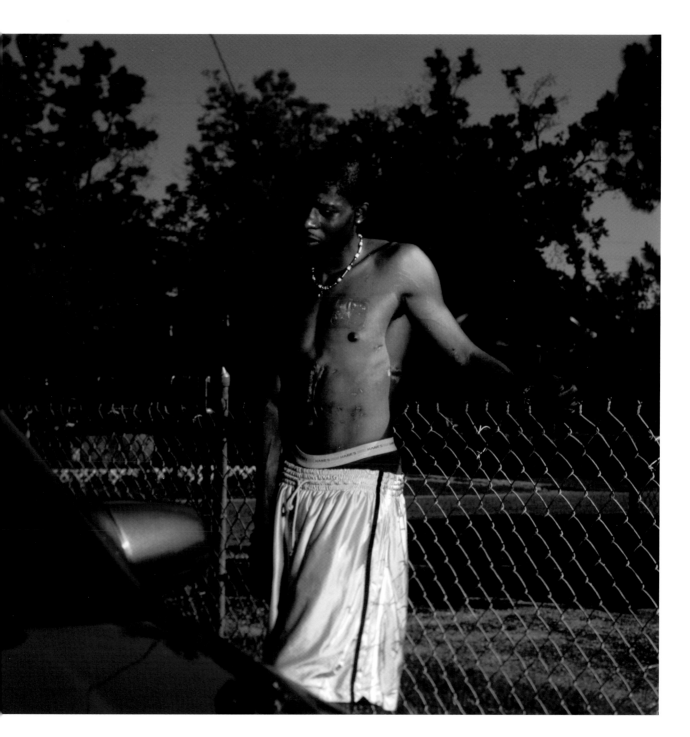

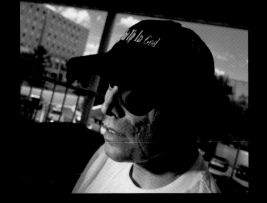

Spc. Carl Sampson, 36, an Army Reservist with the Mississippi National Guard 890th Engineering Battalion, was injured by a roadside bomb September 12, 2003, in Fallujah. He lost his left eye, his face was shattered, 5 percent of his brain volume was removed and he was unable to talk or move for months. He is starting to regain limited motor and speech skills.

Photographed at the Tampa Veterans Hospital, accompanied by his aunt Mona, May 17, 2004

"I just don't have nothing anymore"

Carl: *I went through all them months asleep. Didn't know where I was. Didn't know where I was. I don't remember nothing. I just wish I could talk about the, the. I wish I could get my. If I get it working. I would be all right.*

Mona: *He knows he's not saying the right word for what he's thinking. It's just his words can't match up yet because of the brain injury.*

Carl: *I never figured I'd be cuffed as much as I am. I figured they would, they would be a blow on us, then all of a sudden get hurt, got hurt bad, but then they asked who was willing to be one of these. Hard to be suffering. I told them I'd do it. It takes a good person to be sympathize and I like to be handy.*

Mona: *He would volunteer for things no one else wanted to do. He's always been that type. That's what he's trying to say.*

Carl: *I just don't have nothing anymore.*

Mona: *He's talking about his wife. She's left him now but you're all right aren't you. There's someone out there that's going to love you.*

Carl: *That's what I'm hoping for.*

Mona: *He told his mom that he signed up to go. It was because all of his cousins and buddies were there and he didn't want them going over by themselves. His mother begged him not to. You wish you wouldn't have went now, don't you?*

Carl: *Yes.*

(Spc. Sampson was not awarded a Purple Heart until a congressman interceded on his behalf. The congressman speculated in the press that Sampson and four other members of the Mississippi National Guard who were wounded in the attack were not awarded medals because the Pentagon was trying to under-report combat injuries.)

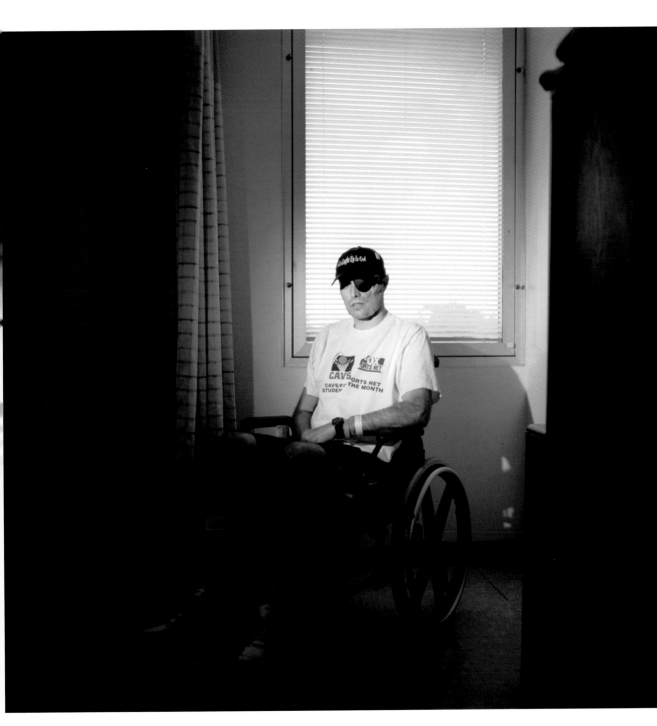

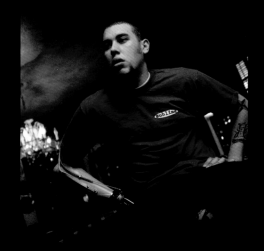

————————

Spc. Robert Acosta, 20, an ammunitions specialist with the 1st Armored Division, was in a humvee near Baghdad International Airport July 13, 2003 when a grenade was thrown into his vehicle. In the explosion he lost his right hand and the use of his left leg.

Photographed at his home in Santa Ana, California, April 13, 2004

"All the reasons we went to war,
it just seems like they're not
legit enough for people to lose
their lives for"

The first real eye opener was like just driving through the desert and seeing vehicles blown up and uniforms everywhere and I guess the aftermath of war, and just like people throwing rocks, like the hatred of people, the love of people. A lot of things that people aren't supposed to see like destruction and houses where like people lived, just destroyed, like little kids in the middle of nowhere. You know they don't have no families. It looked like it had the potential to be a really pretty city but it was like mangled, just destroyed.

It was July 13. I think like three guys were killed the day I was injured. It was broad daylight, like 1800 hours and the grenade flew in the window, landed on the radio between me and my buddy. It went off in my hand, took my hand off, shattered my left leg, broke my right ankle, blew the whole body of the humvee out. My buddy Anthony, he was fine, nothing happened to him. I remember asking him are you alright, and he said, "yeah are you?" and I said, "no dude, my hand is gone." I was telling him man, I don't think I'm going to make it and he was telling me to shut up. He got me back. He's in Germany right now. He got out because of like psychological or whatever. It messed him up,

At Walter Reed, it tripped me out. I guess you hear about guys getting hit and this and that but you don't realize until you actually see them. Because when somebody gets hurt, they're out of there within hours. You hear rumors, you hear stories, some guy got hit, some guy that, but you don't really see the reality of it until you get there and see them in the hospital. It's a trip when you're one of those guys too. I mean we would go to the mall and it would be like me missing my hand, my buddy Ed missing a leg, my buddy Chris missing his whole arm. We're all in crutches or wheelchairs, whatever, and they're just like five or six of us going through the mall, soldiers just back from the war, mad at the world just talking shit to everybody.

But like in California, nobody really knows what the soldiers are going through. They see on TV, oh yeah, two soldiers got wounded today and they think, yeah, he'll be all right. But that soldier is scarred for life both physically and mentally. But like they don't understand. They see one soldier wounded and they'll forget about it like as soon as they change the channel. Some people get brave and they'll ask me, "what happened to your hand?" And I say, "I was in Iraq, got injured, lost my hand," whatever. And they're like, "the war's still going on?" And I'm like, oh my God, are you serious? What do you live in a fucking cave?

Before I would go to a lot of parties. I would go to a lot of clubs. I was always out and about. I haven't been to a club. I haven't been to a party. I don't care what people think, I just don't like

dealing with the questions. Like, "was it hot? Did you shoot anybody?" They want me to glorify war and say it was so cool and it was like I did this and that. They're just ignorant. I mean you watch action movies and they glorify all this stuff like war is something cool, like it's something you want to do. But the reality of it is, seeing all that crap, fucks you up in the head, man. I can't sleep at night. It sucks. It really sucks.

You know Santa Ana really isn't the best place in the world. Opportunities in this town are very hard to come by. The education is just out the window. Like my brother went to high school this year. He's a freshman, and like he had to sit on the floor in some of his classes. The books are all written in, it's just graffiti and pages torn out. That's how it was when I went to high school, like the people don't care.

There's a lot of stuff that happens around here. You go to parties and see people get shot up. I mean I grew up seeing a lot of stuff. Lost a lot of friends from drugs too. I mean my best friend from junior high is strung out on meth. I kicked him out of my house the other day. It hurt, but I can't deal with that. I probably would have been one of the many that got caught up in some wrong situation. So I mean getting out of here was like the best thing I've ever done because you leave, you leave.

I loved the military. It was my life. I loved it. I miss being in the military because it's like I had a routine. I was good at what I did. I had friends. I was successful. I was happy. And it was kind of like all taken away from me.

Yeah I got a Purple Heart. I don't care. No soldier wants a Purple Heart. I'll tell you that much. No soldier wants it. Awards don't mean nothing to me. I don't need anything to prove I was there. I know I was there. I got a constant reminder.

I mean like all the reasons we went to war, it just seems like they're not legit enough for people to lose their lives for and for me to lose my hand and use of my leg and for my buddies to lose their limbs. Like I just had a big conversation with my buddy the other day and like we want to know.

I feel like we deserve to know.

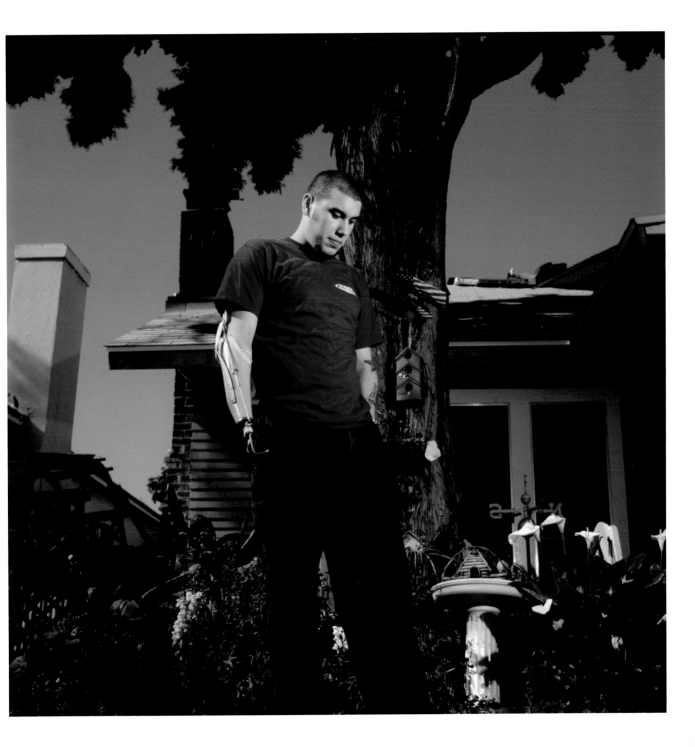

Today, as I read the accounts of wounded soldiers returning from Iraq and see the pictures in this book, the voices of these young men seemed to echo the voices of those with whom I once served. Like sorrowful calling cards from a haunted history, these images remind me of the exact moment I was forced by an unsympathetic reality to accept responsibility for my own life decisions.

I was nineteen years old when I suffered my injuries. I was a combat Marine in Vietnam during the Tet Offensive in 1968. I had quit college and football to volunteer in my country's war, a willing participant determined to do my patriotic duty, like so many of the soldiers in this book. In my mind I was a heroic and invulnerable figure — I was going to win the war on my own — which made my overnight transformation to one of America's disabled nearly incomprehensible. A booby-trap 105 mm artillery round detonated from ambush sent me flying forty feet in the air near the DMZ north of Danang. When I returned to earth my left knee and left heel were gone and my femoral artery had been severed. The quick work of a medic brought me back to the world but I would soon discover it would never be the world I had so recently departed. I would bury the "Doc" who saved my life three months later when he became the victim of a VC sniper. I spent the next year in hospital with other disabled and disfigured young men. My transformation from a rugged, 6 ft. 5 college football player to a severely injured amputee was accompanied by memories of the vilest of possible human behavior that haunt the major-ity of combat veterans for the rest of their lives. We are brothers in blood bound together from one generation to the next. For us it is not necessary to imagine what is going through the minds of these young soldiers. We, as veterans of Vietnam, have already lived the next thirty years of their lives. Today they are making the difficult transformation from their beloved status as "our troops," and "our heroes," to that simple category —

Veteran. I can only warn them that in American culture, this is not a promotion.

I have heard the patriotic language of "service" and "support" before and hearing it now, in the context of another armed conflict, raises within me a deep and profound sadness. In my life there was a time when friends and family members, in their patriotism and righteous morality, gave strength to my naive innocence. I wanted to join. I begged to join. I asked eight times to be sent to Vietnam. When my request was finally honored, I attacked the windmills of "communist dominoes" like Don Quixote only to awaken, literally from the dead and to the discovery that I had become an old man. I remember the night I arrived in Vietnam. We flew into Danang airport and we were shelled. We ran from the plane, heads down. I had arrived to liberate a country. I was there to win their hearts and minds. I was going to help determine the future for a people whose language I did not know and whose history was a complete mystery. I had, along with thousands of my brothers, been given the power of life and death. "I was only doing my job."

Over thirty years have since passed. Despite a wife and friends and a loving community, I often feel I am a ghost in a world where little is substantial and even less seems real. My truth was shattered and I paid a heavy price for the education. Unfortunately, I am not alone. For the soldiers today, even those who have returned physically unharmed, it may be years before they sleep less than fitfully through the night. They will awaken in cold sweats, striking out at nightmare enemies trapped within the terror of another time. They will find them selves becoming depressed as they gaze into the faces of small children (including their own.) They will feel guilt and anger for having returned when others with whom they have served did not. Even the smallest of aggravations and disappointments in life will bring to the surface a seemingly inexplicable anger. They will attempt to describe to others what they have seen and

experienced but for the vast majority of those among whom they must live, this will never be possible. There will never be adequate words. Only those who know will know.

As has proven to be the case time and again in other wars, the causes for conflict most often do not originate between warriors. As a young Marine I had no personal quarrel with the people of Vietnam. The quarrel belonged to heads of state and commerce that claimed to represent their people. It is these individuals, always found at that geographic point farthest from all possibility of personal harm, who consistently place us, their citizens, into the path of ever-present danger. Because we as veterans know war, it then becomes our task to help others understand the true consequences of war. We must continue to serve but not without question; learning first to make the necessary distinctions between those things in which we as a culture truly believe and the personal desires of those who would not hesitate to take advantage of our idealism for personal gain or profit. For today and for myself I know it to be true that war in any form is an outdated concept offering only short-term solutions and providing only the guarantee of its own self perpetuation. Until literacy again resurfaces in our culture I personally believe it will be necessary to push a mix of text and images such as yours into the faces of our contemporaries to awaken them from their comfortable and complacent dreams.

Tim Origer USMC-VIETNAM-TET 1968 —
Veterans For Peace.

My deepest thanks to all those who helped bring this book to life: The soldiers and their families. Gigi Giannuzzi and everyone at Trolley. Writers Verlyn Klinkenborg and Tim Origer. Jasmine Jopling, Marcel Saba, Kristy Reichert and good friends at Redux Pictures. MaryAnne Golon, Hillary Raskin and Maria Bunai at *TIME Magazine*. Monika Bauerlein, Sarah Kehoe and Rina Palta at *Mother Jones*. Jean-Jacques Naudet at Hachette Filipacchi. Mark Benjamin at *UPI*, Larry Schills at the *Salem News* and Liz Zemba at the *Tribune Review*. John Melia at the Wounded Warrior Project, Ted Roeder at the United Spinal Association, Troy Ephriam of the Prichard City Council, Steve Brosack, Dr. Steven Scott, Carolyn Clark, Susan Ward and Norma Guerra. I want to especially thank Sue Brisk for showing the pictures to Gigi, and Carmine Galasso and my family for living with this project and being there with love and support.

Published in Great Britain in 2004 by Trolley Ltd.,
www.trolleybooks.com

Photography and interviews © Nina Berman, 2004.
Introduction © Verlyn Klinkenborg, 2004.
Afterword © Tim Origer, 2004.

10 9 8 7 6 5 4 3 2 1

A catalogue record for this book is available from the British
Library

ISBN 1-904563-34-1

Printed in Italy by: Soso Industrie Grafiche S.p.A.